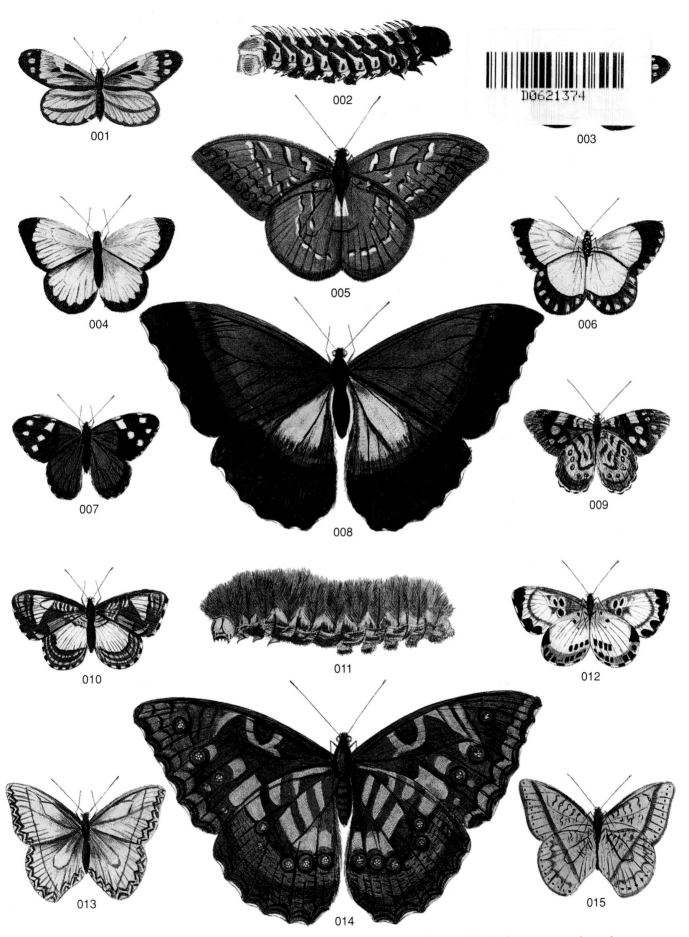

PLATE 1. BUTTERFLIES. 001, 003: *Heliconius hecale.* 004, 006: *Colias palaeno.* 005: *Archaeoprepona demophon.* 007, 009: *Eunica orphise.* 008, 014: *Morpho telemachus.*

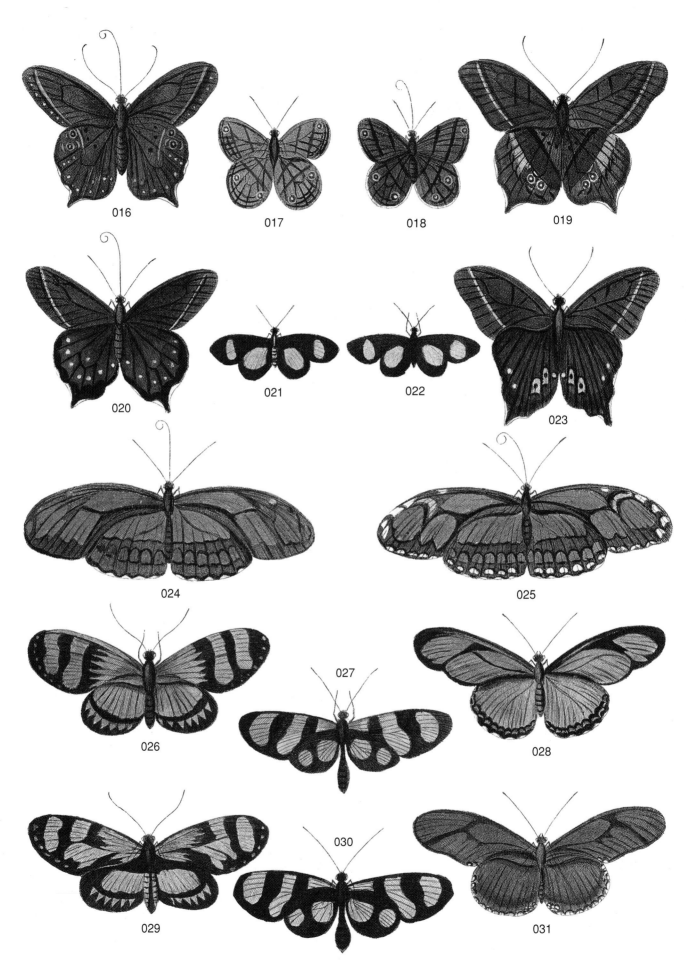

016 017 018 019

020 021 022 023

024 025

026 027 028

029 030 031

PLATE 2. TROPICAL AMERICAN BUTTERFLIES. 017, 018: Satyridae. 019, 023: *Antirrhea philoctetes.*
021, 022, 026–31: Heliconiidae. 024, 025: *Philaethria dido.*

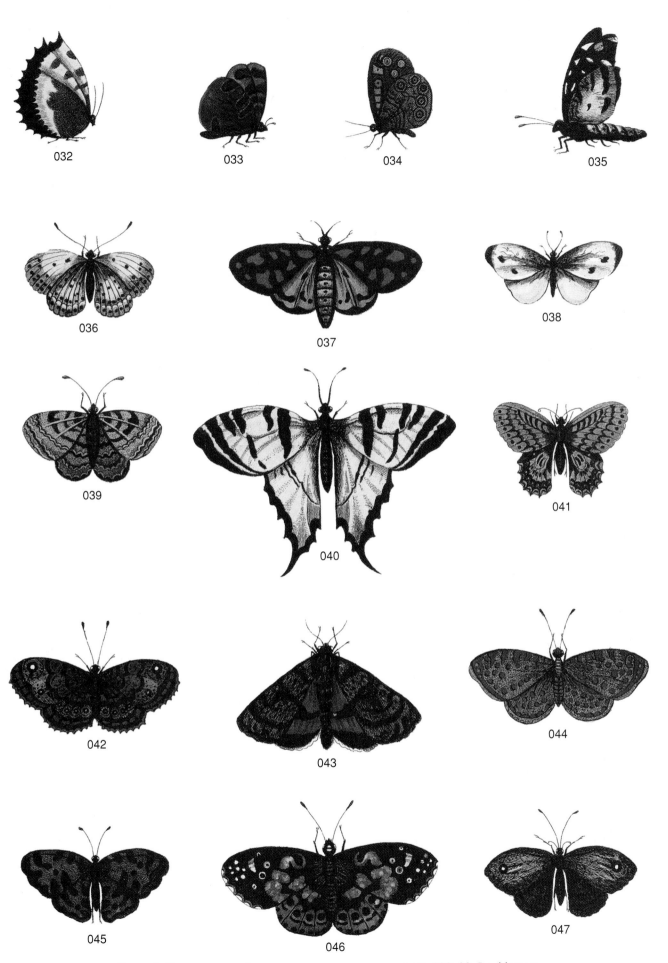

PLATE 3. EURASIAN AND AMERICAN BUTTERFLIES AND MOTHS. 032–39: Lepidoptera.
040: *Iphiclides podalirius*. 043: *Catocala*. 046. *Hamadryas feronia*.

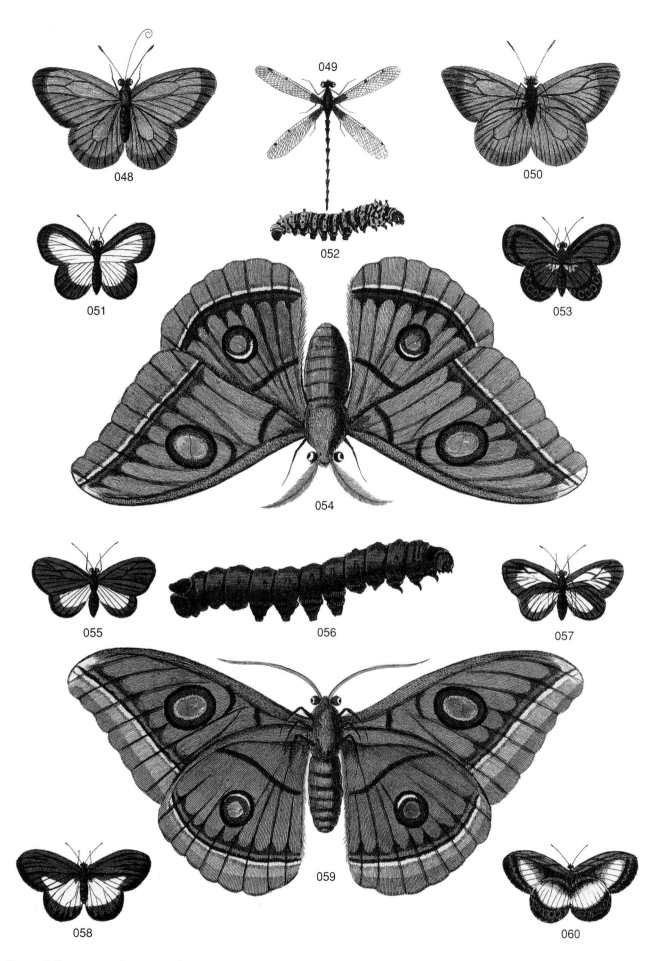

PLATE 4. SOUTHEAST ASIAN AND AUSTRALIAN BUTTERLIES AND MOTHS. DRAGONFLY. 049: Odonata. 051, 053: *Danis*. 054, 059: *Antheraea helferi*. 055, 057: Polyommatinae. 058, 060: *Danis danis*.

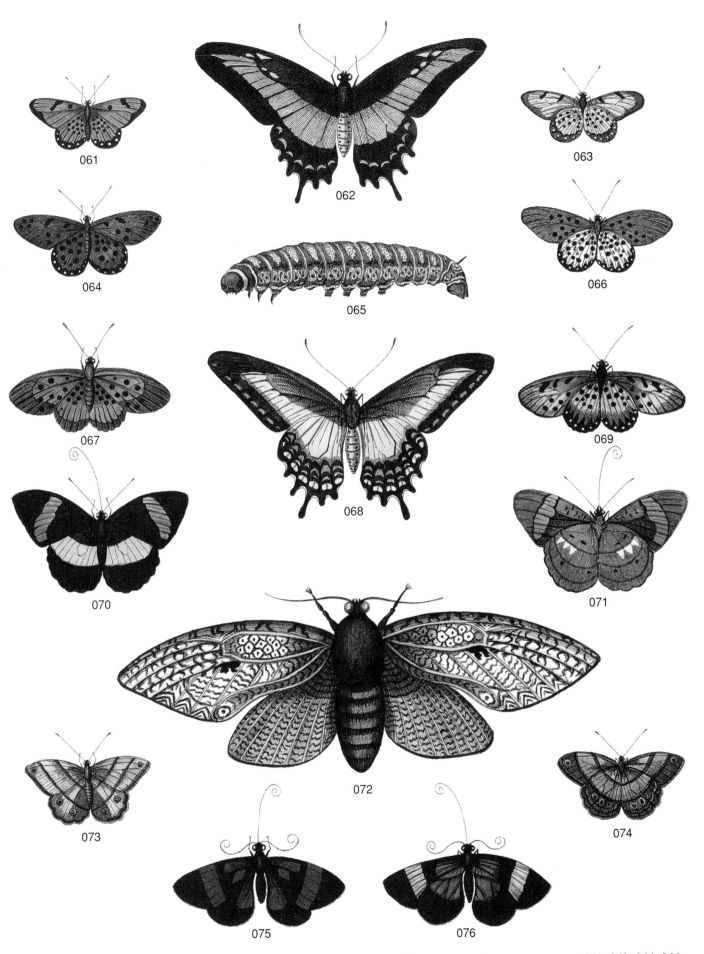

PLATE 5. SOUTH AMERICAN AND AFRICAN BUTTERFLIES; MALAYSIAN, NEW GUINEAN, AND AUSTRALIAN MOTHS. 061, 063, 064, 066: Nymphalidae. 062; 068: *Papilio* sp. 067, 069: *Acraea horta.* 072: *Xyleutes strix.*

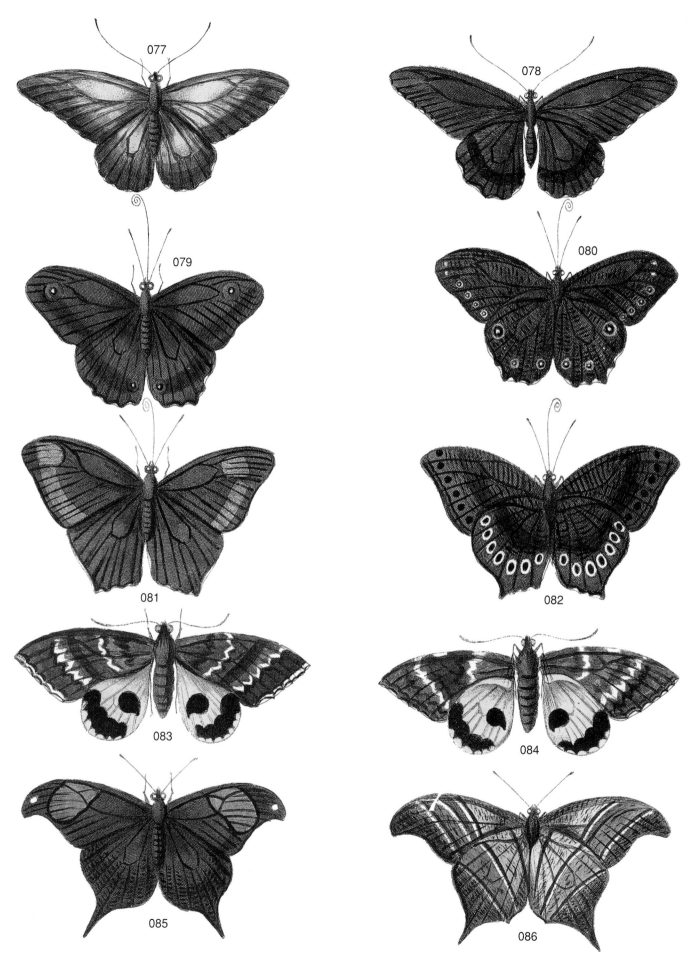

PLATE 6. BUTTERFLIES AND MOTHS FROM TROPICAL AFRICA TO AUSTRALIA AND FROM CENTRAL AND SOUTH AMERICA.
079, 080: *Melanitis leda.* 085, 086: *Caerois chorineus.*

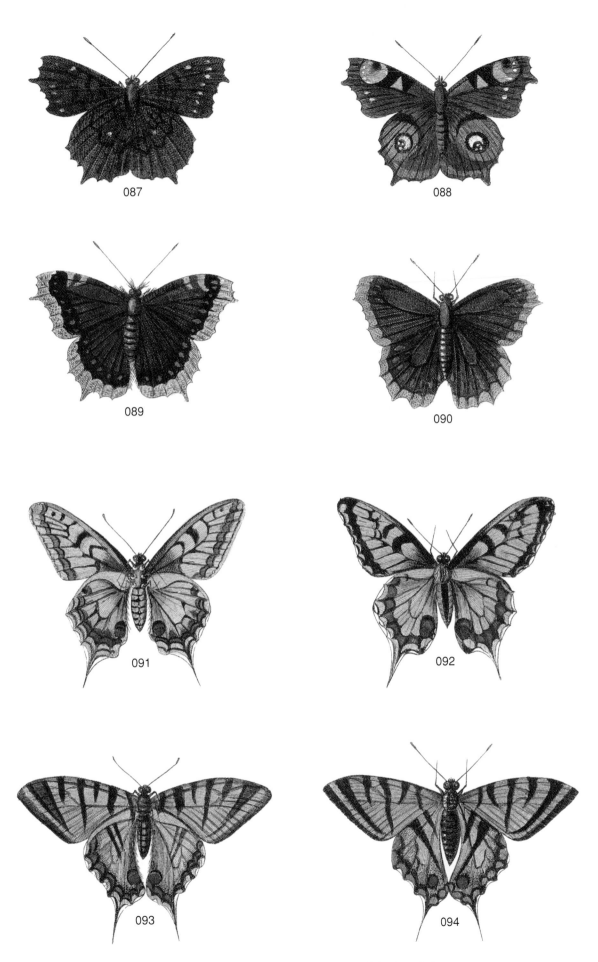

PLATE 7. BUTTERFLIES. 087, 088. *Inachis io.* 089, 090. *Nymphalis antiopa.*
091, 092: *Papilio machaon.* 093, 094: *Iphiclides podalirius.*

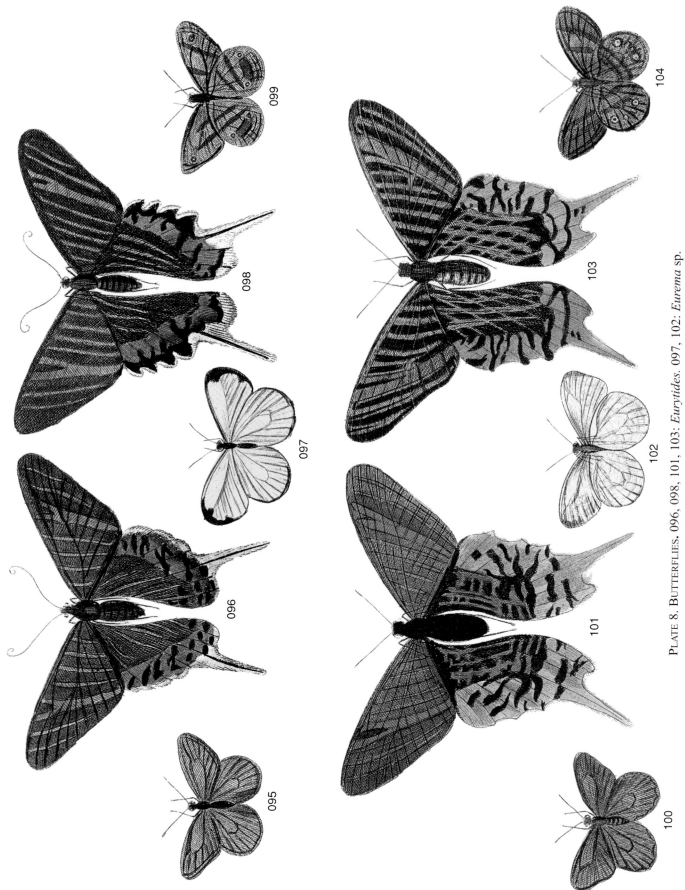

PLATE 8. BUTTERFLIES. 096, 098, 101, 103: *Eurytides*. 097, 102: *Eurema* sp.

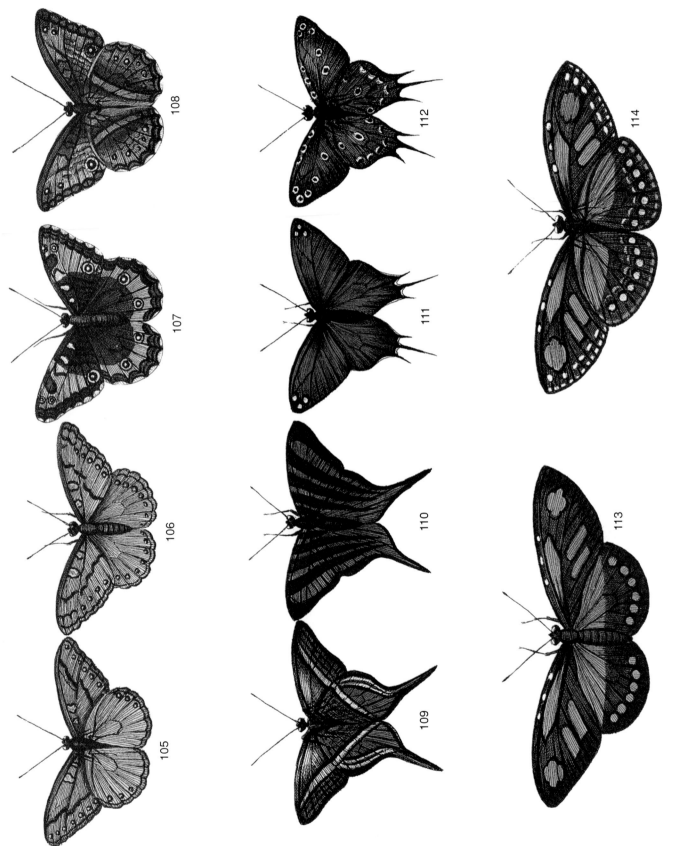

PLATE 9. AMERICAN AND SOUTHEAST ASIAN BUTTERFIES. 109, 110: *Marpesia chiron.* 111–112: *Pseudolycaena marsyas.*

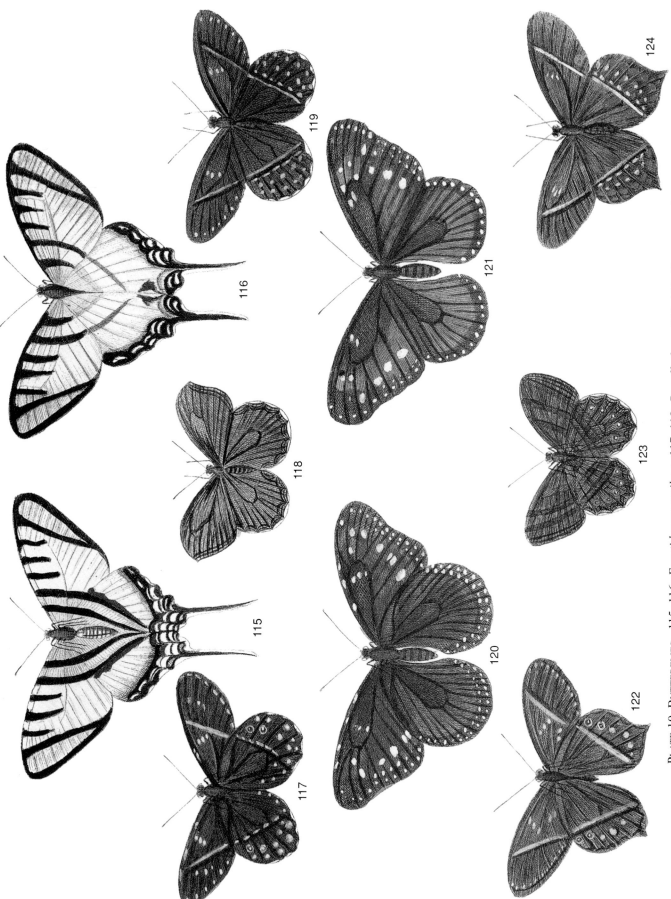

PLATE 10. BUTTERFLIES. 115, 116: *Eurytides protesilaus*. 117, 119: *Pierella lena*. 120, 121: *Danaus eresimus*.

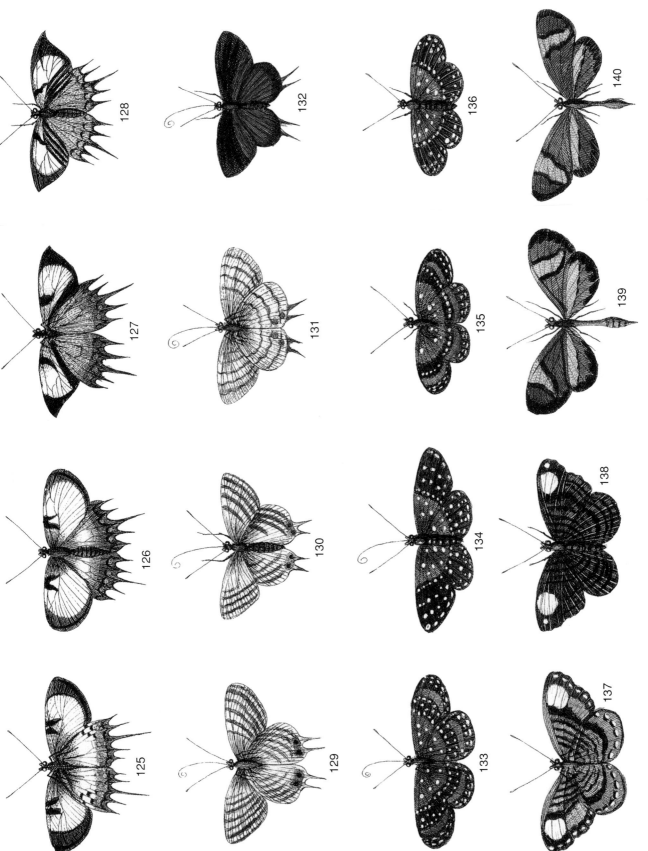

PLATE 11. CENTRAL AND SOUTH AMERICAN TROPICAL BUTTERFLIES. 125–128: *Helicopus cupida.* 133–136: *Stalachtis phlegia.* 137, 138: *Emesis lucinda.* 139, 140: Ithomiinae.

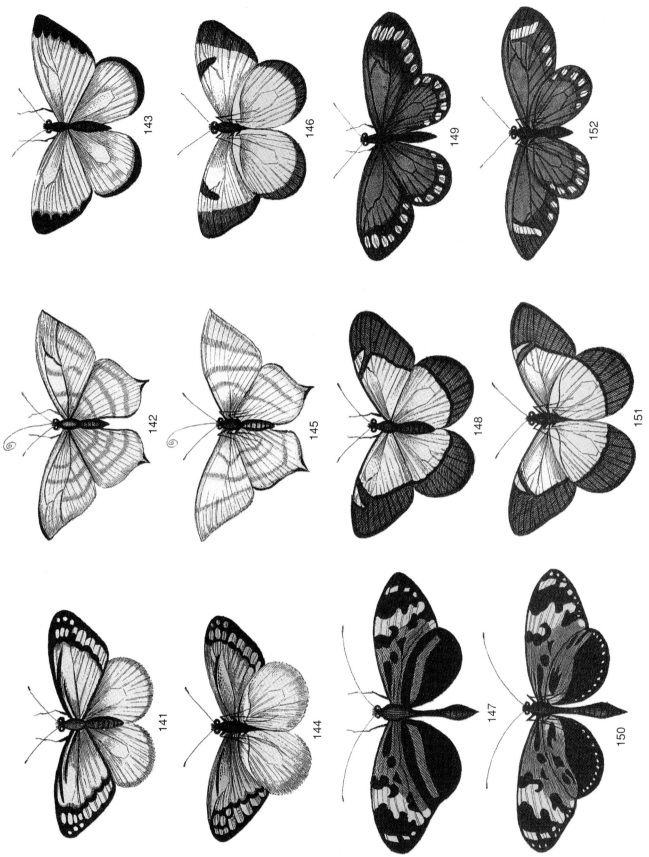

PLATE 12. SOUTH AMERICAN AND SOUTHEAST ASIAN BUTTERFLIES AND MOTHS. 141, 144: Pierinae. 142, 145: Coliadinae. 143, 146: *Melete lycimnia.* 147, 150: *Melinaea mneme.*

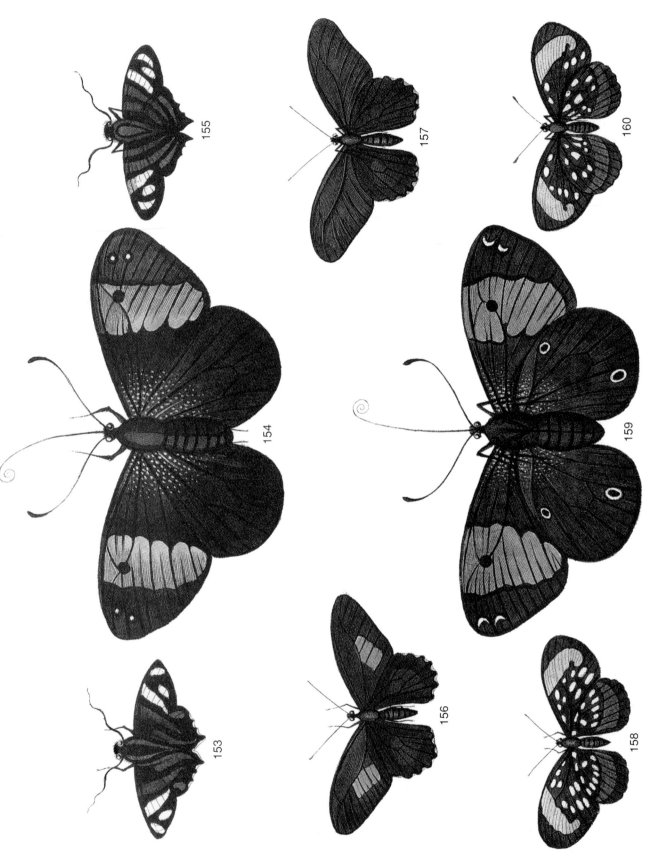

PLATE 13. SOUTH AMERICAN TROPICAL BUTTERFLIES. 153, 155: *Jemadia gnetus.* 154, 159: *Brassolis sophorae.* 156, 157: *Parides aeneas.* 158, 160: *Stalachtis euterpe.*

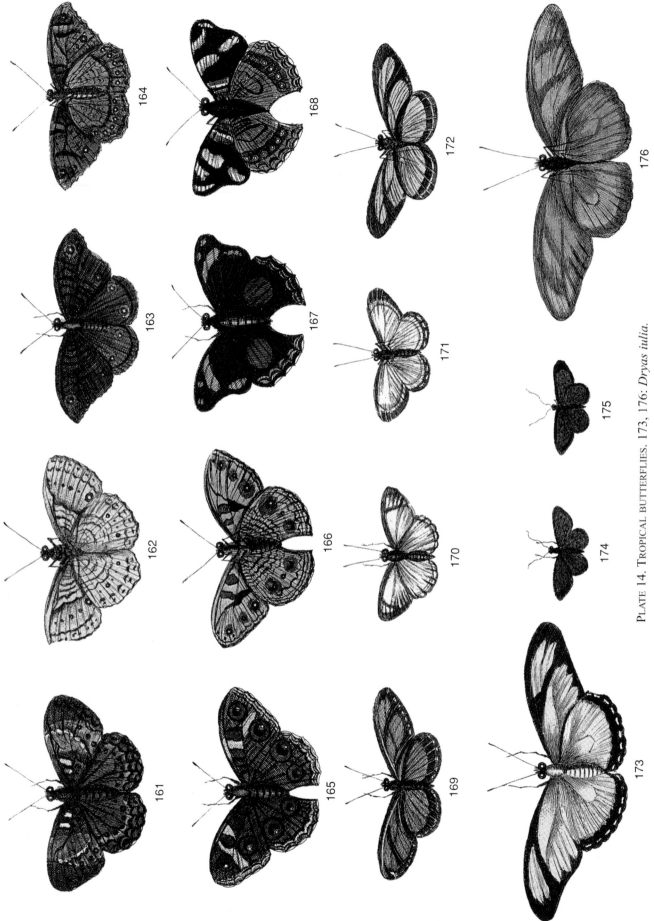

PLATE 14. TROPICAL BUTTERFLIES. 173, 176: *Dryas iulia*.

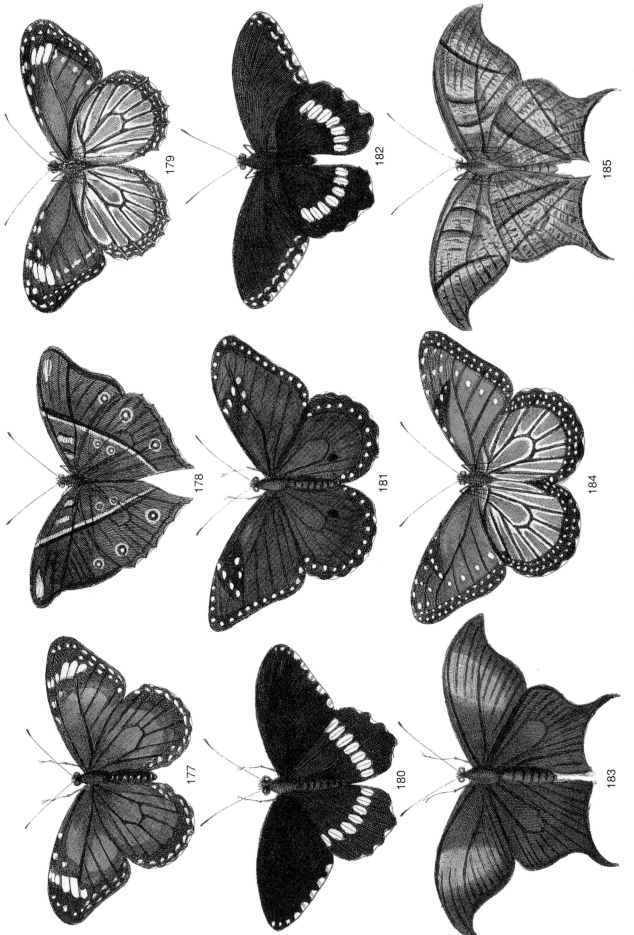

PLATE 15. TROPICAL BUTTERFLIES. 177, 179: *Danaus genutia*. 180, 182: *Papilio polytes*. 181, 184: *Danaus plexippus*. 183, 185: *Caerois chorineus*.

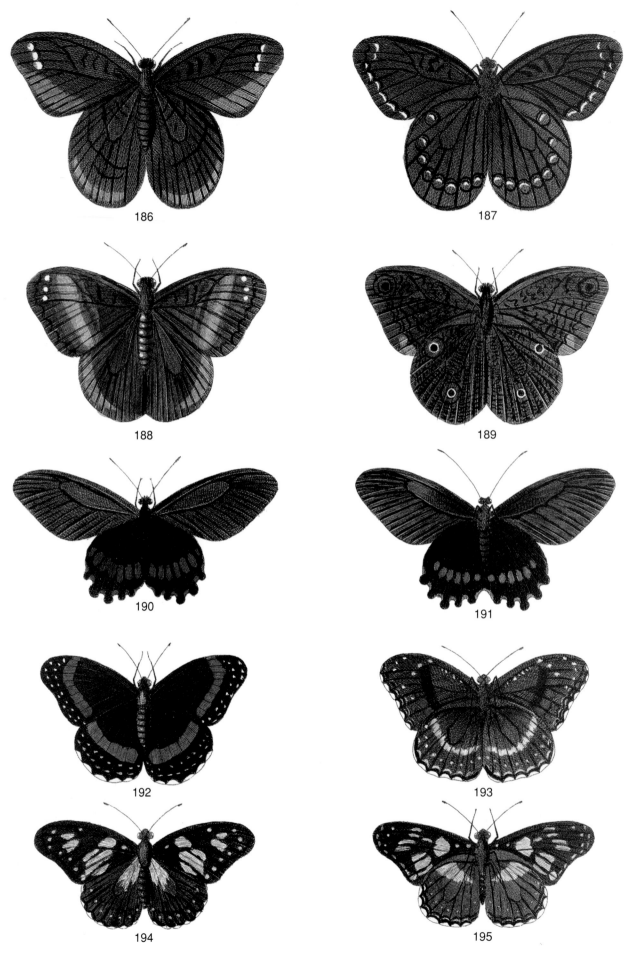

PLATE 16. BUTTERFLIES FROM MALAY ARCHIPALAGO, NEW GUINEA TO AUSTRALIA AND SOUTH AMERICA. 186–189: Nymphalidae. 190, 191: *Parides anchises*. 192, 193: *Hypolimnas alimena*. 194, 195: Papilionoidea.

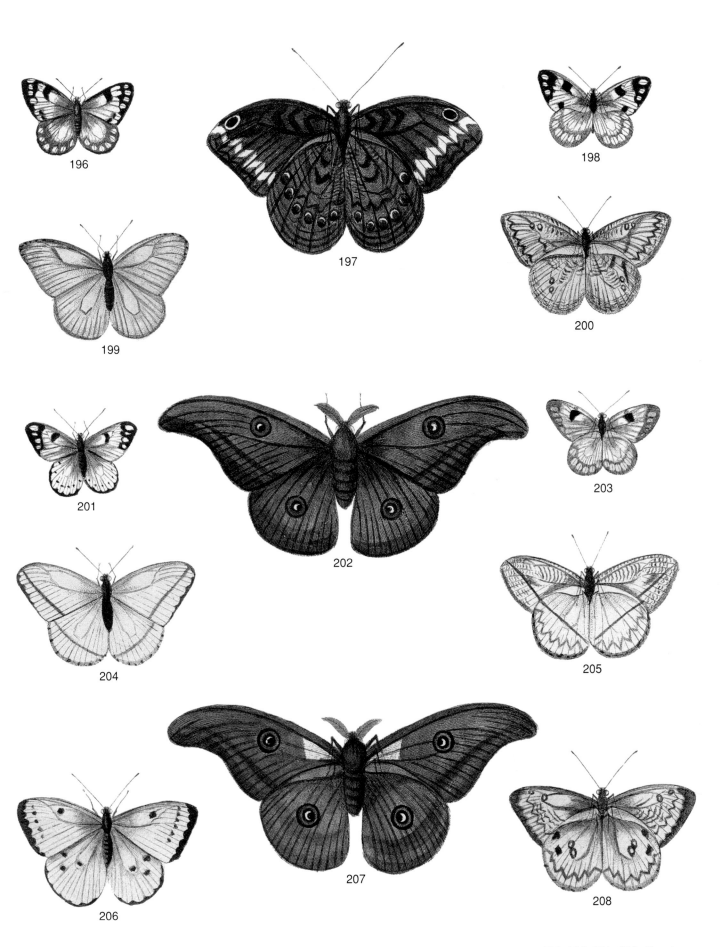

PLATE 17. EUROPEAN, AMERICAN AND NORTH AFRICAN BUTTERFLIES; SOUTHEAST ASIAN SILKMOTHS. 196, 198, 201, 203: *Pontia daplidice.* 199, 200, 206, 208: *Phoebis sennae.* 202, 207: *Antheraea helferi.* 204, 205: *Phoebis trite.*

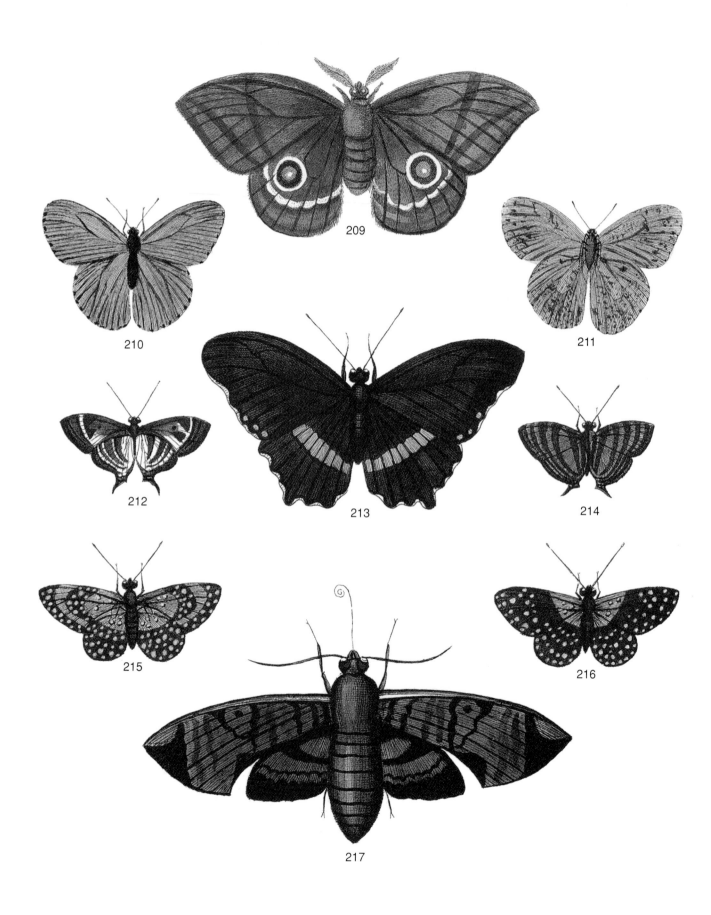

PLATE 18. BUTTERFLIES AND MOTHS. 213: *Papilio polytes.* 215, 216: *Stalachtis phlegia.* 217: *Pachylia ficus.*

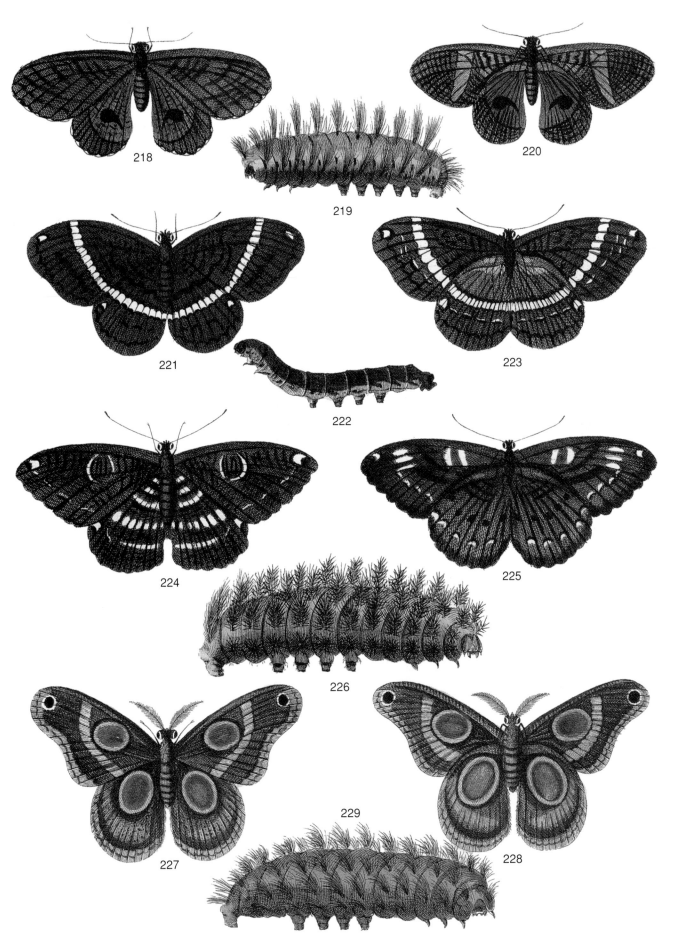

PLATE 19. INDONESIAN AND NEW GUINEAN BUTTERFLIES; CENTRAL AND SOUTH
AMERICAN SILKMOTHS. 227, 228: *Rothschildia prionia.*

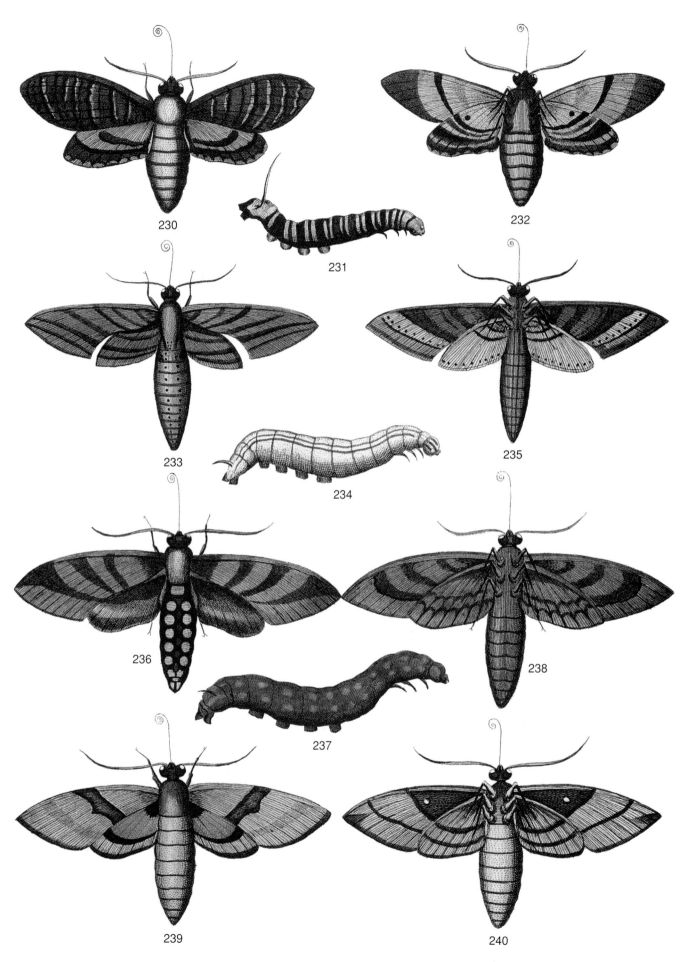

PLATE 20. HAWKMOTHS. 230, 232: *Acherontia atropas*. 236, 238: *Manduca occulta*. 239, 240: *Eumorpha labruscae*.

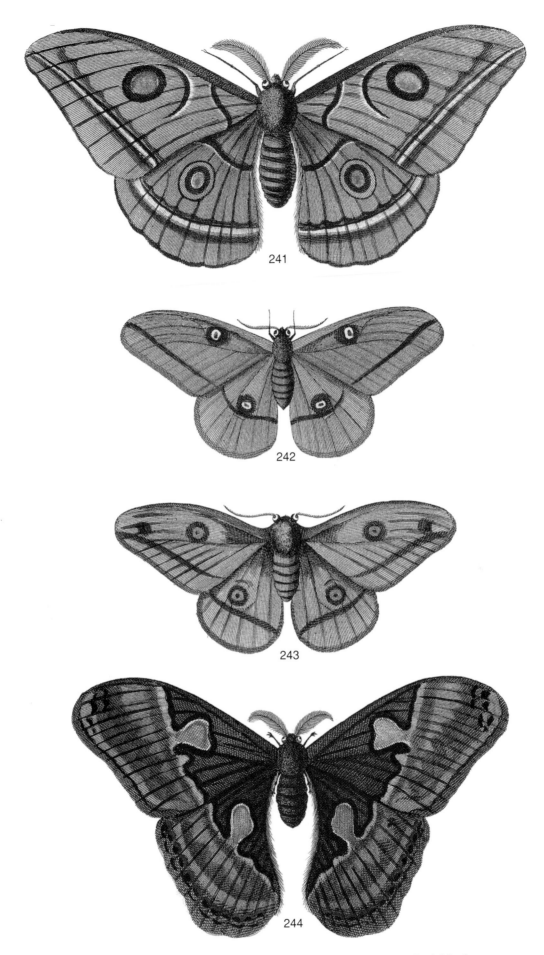

PLATE 21. LARGE TROPICAL MOTHS. 241–243: Saturniidae. 244: *Rothschildia hesperus.*

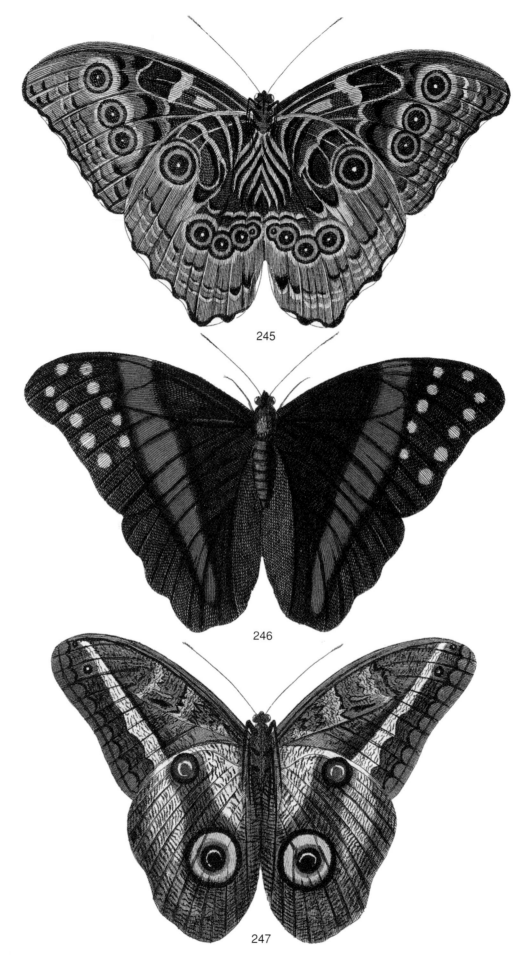

PLATE 22. SOUTH AMERICAN BUTTERFLIES AND TIGER MOTHS. 245: *Morpho*. 246, 247: *Caligo idomeneus*.

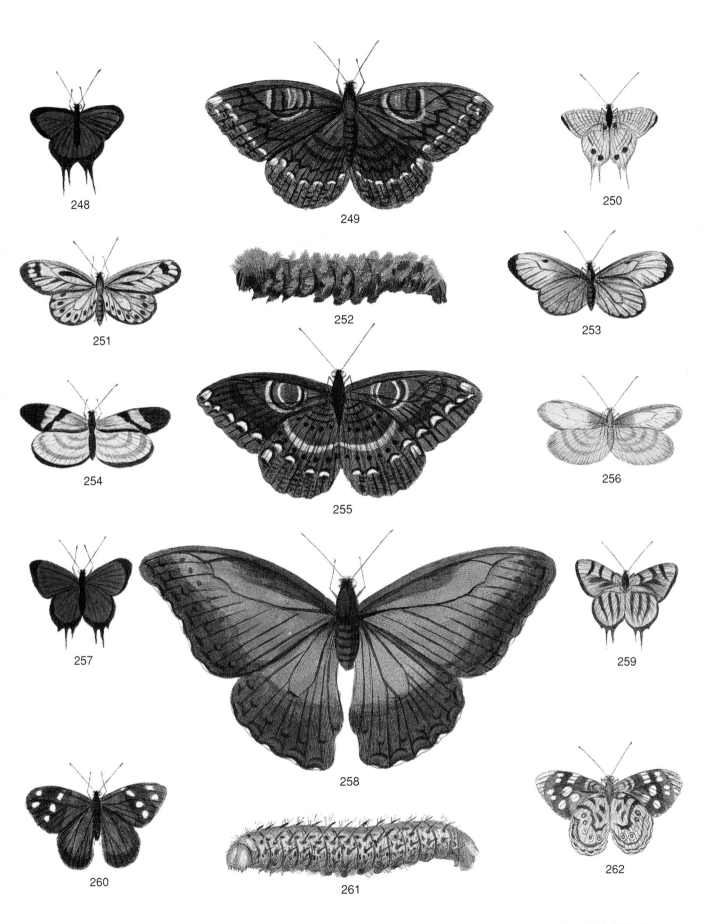

PLATE 23. CENTRAL AND SOUTH AMERICAN BUTTERFLIES. 248, 250: Theclinae. 249, 252, 255: Papilionoidea? 254, 256: *Enantia melite.* 257, 259: *Arawacus.* 258: *Morpho telemachus.* 260, 262. *Eunica orphise.*

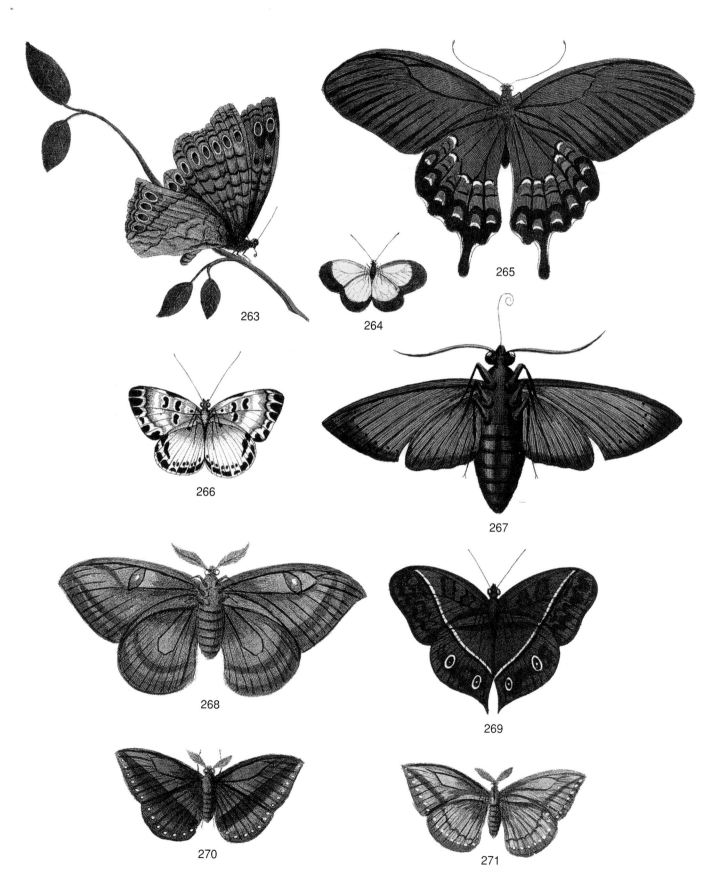

PLATE 24. BUTTERFLIES AND MOTHS. 265: *Papilio* sp. 266: *Salamis anacardi.*
267: *Pachylis ficus.* 269: *Doleschallia bisaltide.*

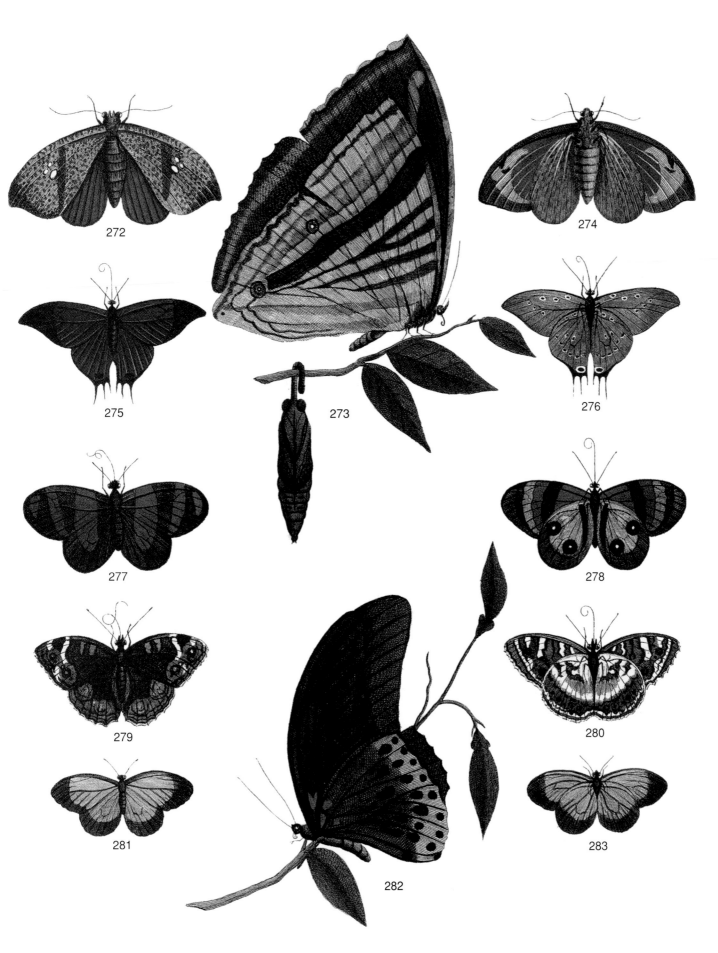

PLATE 25. BUTTERFLIES FROM SOUTHEAST ASIA TO NORTH AUSTRALIA AND FROM AMERICA, AFRICA, AND ARABIA. 273: *Amathusia phidippus*. 275, 276: *Pseudolycaena marsyas*. 277, 278: Satyridae. 279, 280: *Junonia orithya*. 282: *Papilio memnon*.

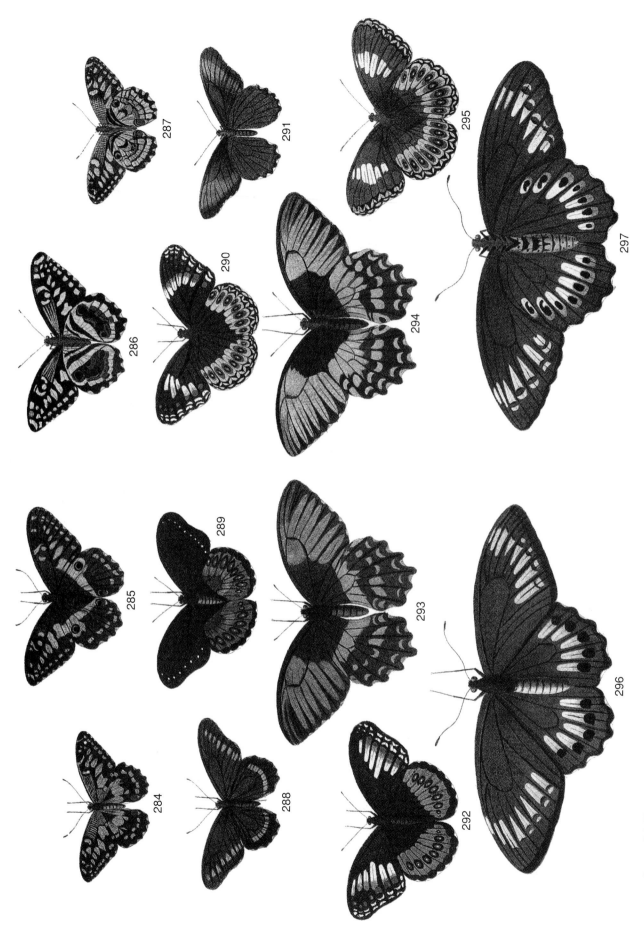

PLATE 26. TROPICAL BUTTERFLIES FROM SOUTHEAST ASIA TO AUSTRALIA AND FROM AMERICA. 284–287: *Papilio demolens.* 288, 291: *Battus polydamas.* 289, 290, 292, 295: *Hypolimnas pandarus.* 293, 294: *Troides helena.* 296, 297: *Troides hypolitus.*

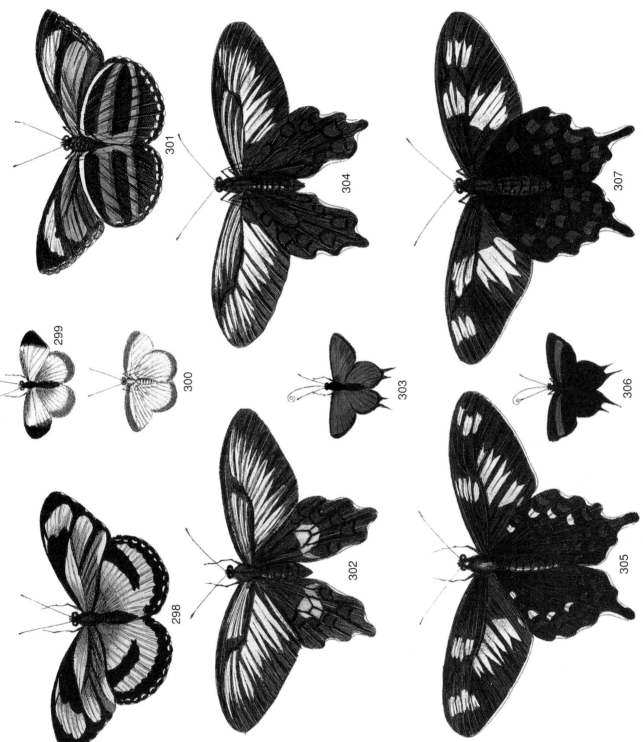

PLATE 27. TROPICAL BUTTERFLIES. 298, 301: *Dryadula phaetusa*. 302, 304: *Atrophoneura polydorus*. 303, 306: Theclinae. 305, 307: *Atrophaneura hector*:

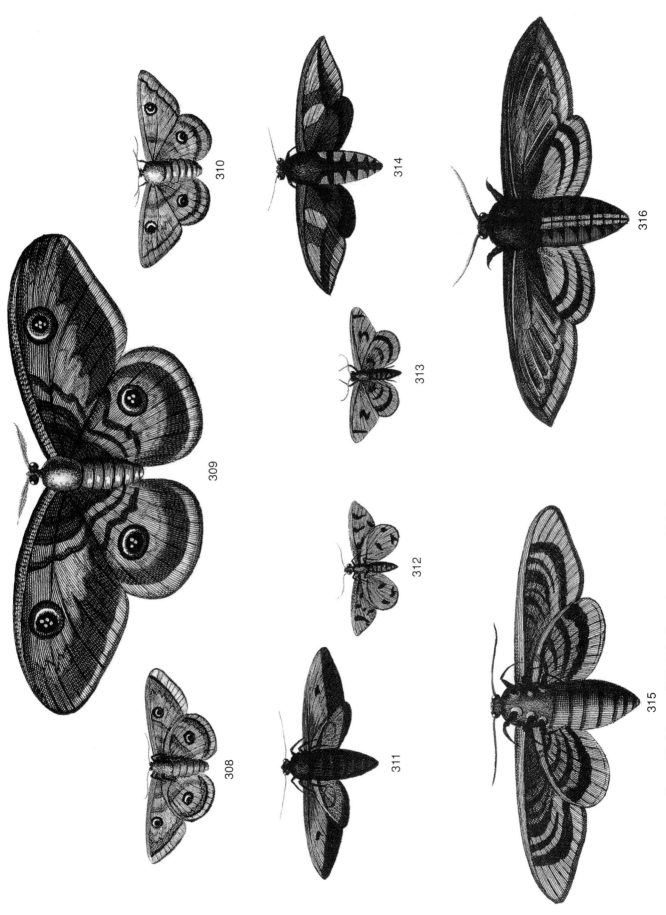

PLATE 28. MOTHS. 308, 310: *Saturnia pvri.* 309: *Saturnia pavonia.* 311, 314: *Hyles euphorbiae.* 315, 316: *Sphinx ligustri.*

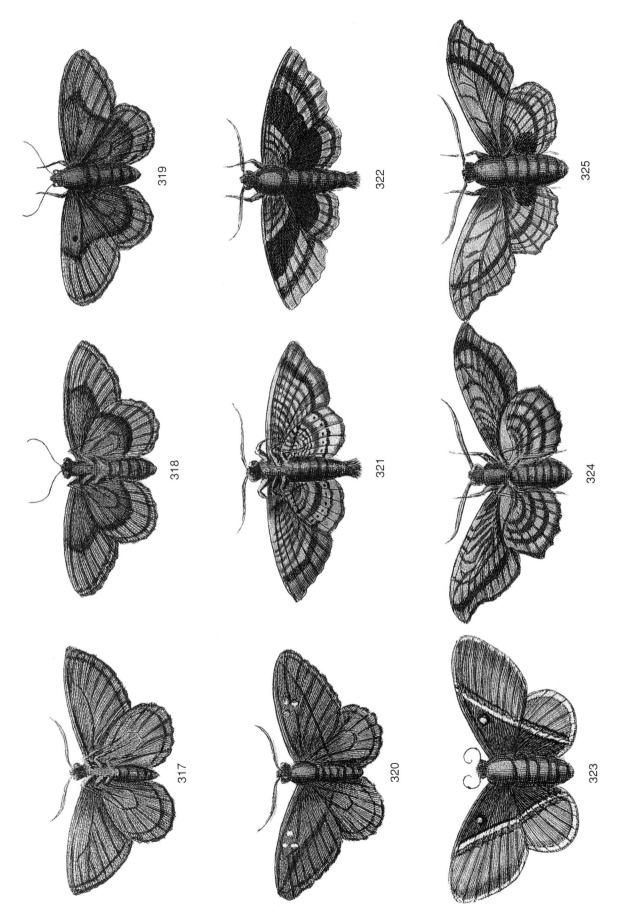

PLATE 29. MOTHS. 317, 320, 323: *Euthrix potatoria*. 318, 319: *Lasiocampa quercus*. 324, 325: *Marumba quercus*.

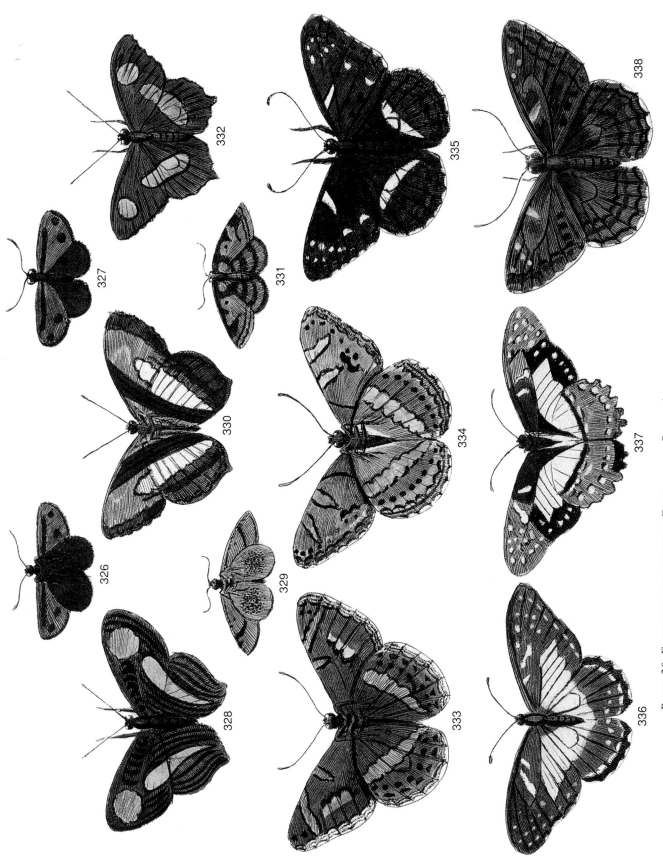

PLATE 30. EUROPEAN AND TROPICAL CENTRAL AND SOUTH AMERICAN BUTTERFLIES AND HAWKMOTHS.
326, 327: Zygaenidae. 332. *Pyrrhogyra neaerea*. 333–335, 338: *Limenitis populi*. 336, 337: Nymphalidae.

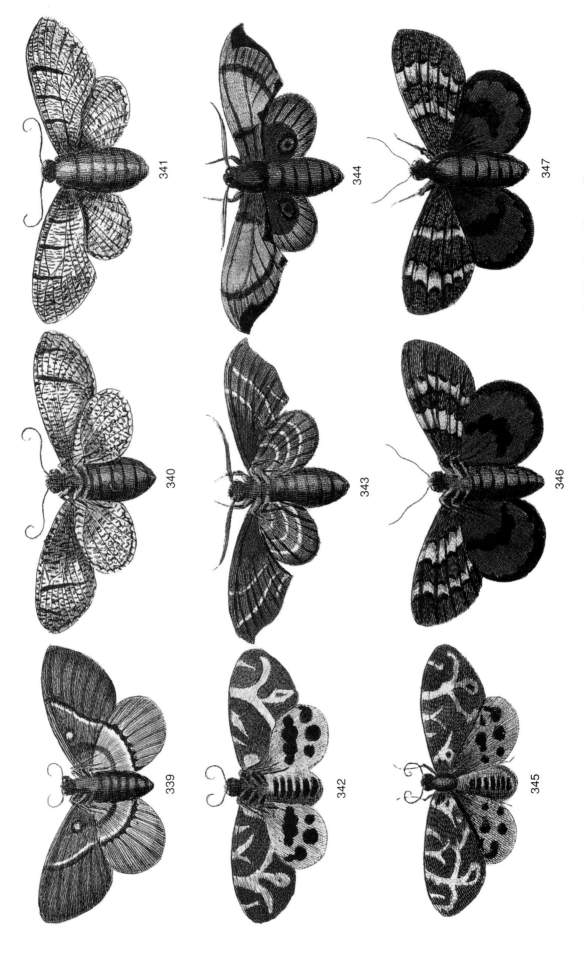

PLATE 31. MOTHS. 339: *Euthrix potatoria*. 340, 341: *Cossus cossus*. 342, 345: *Arctia caja*. 343, 344: *Smerinthus ocellatus*.

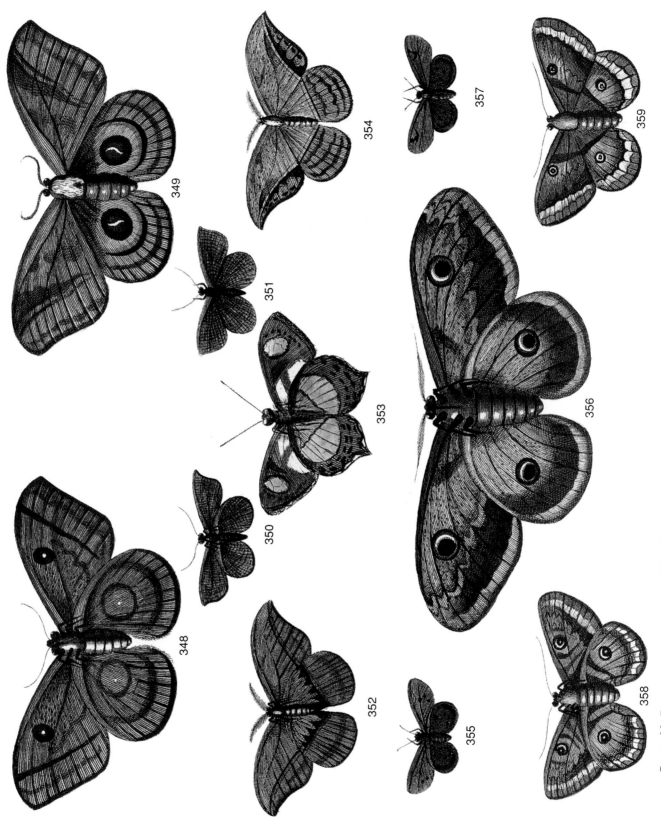

PLATE 32. BUTTERFLIES AND MOTHS. 348, 349: *Automeris.* 353: *Pyrrhogyra neaerea.* 356: *Saturnia pyri.* 358, 359: *Saturnia pavonia.*

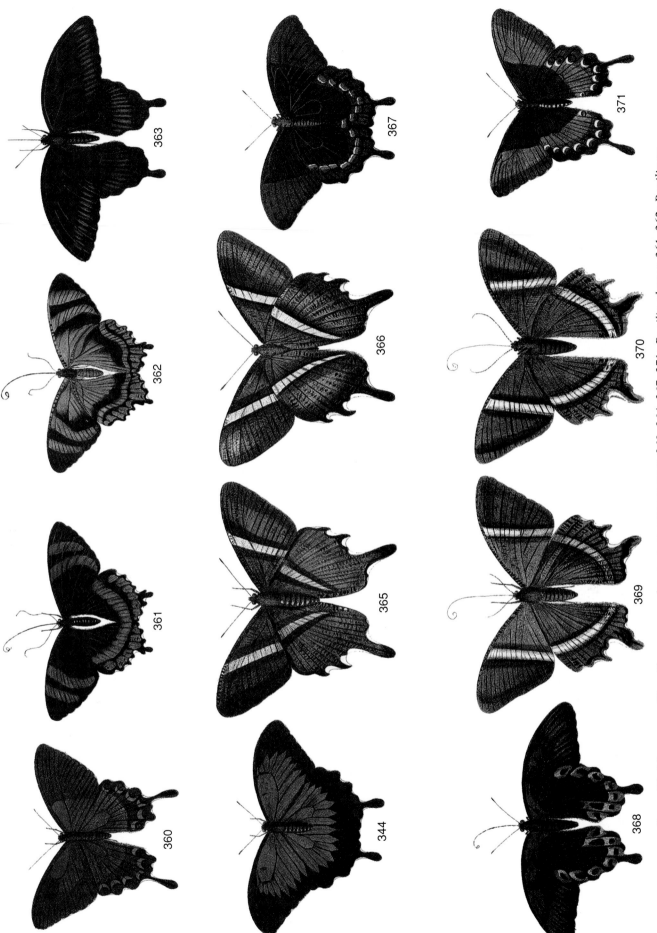

PLATE 33. MALAYSIAN, NEW GUINEAN AND AUSTRALIAN BUTTERFLIES. 360, 364, 367, 371: *Papilio ulysses*. 361, 362: *Papilio* sp. 363, 368: *Papilio deiphobus*. 365, 366: *Papilio oenomaus*. 369, 370: *Papilo hipponous*.

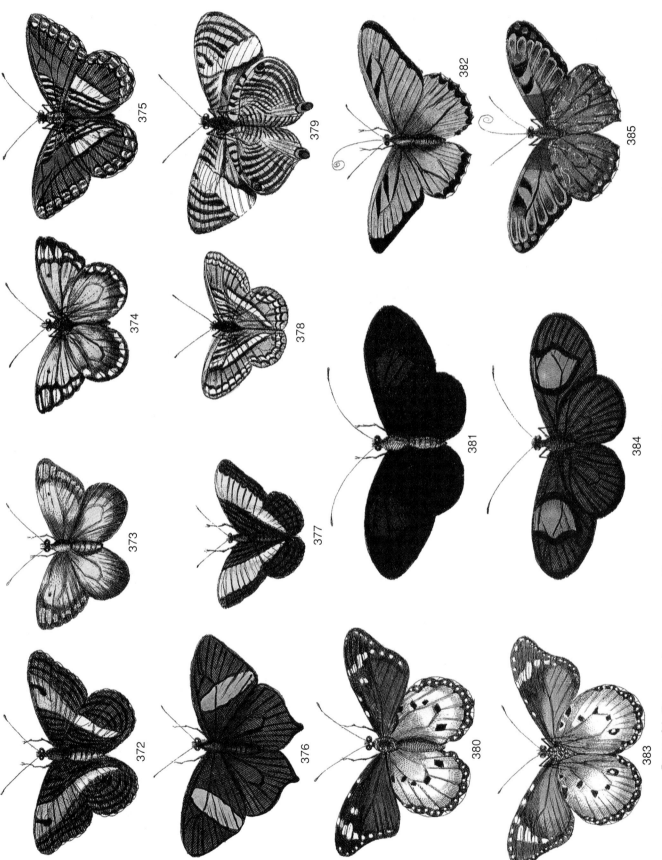

PLATE 34. TROPICAL AMERICAN AND CARRIBEAN BUTTERFLIES. 372, 375: *Adelpha.* 376, 379: *Colobura dirce.* 377, 378: *Adelpha cytherea.* 380, 383: *Danaus chrysippus.* 381, 384: *Heliconius melpomene.*

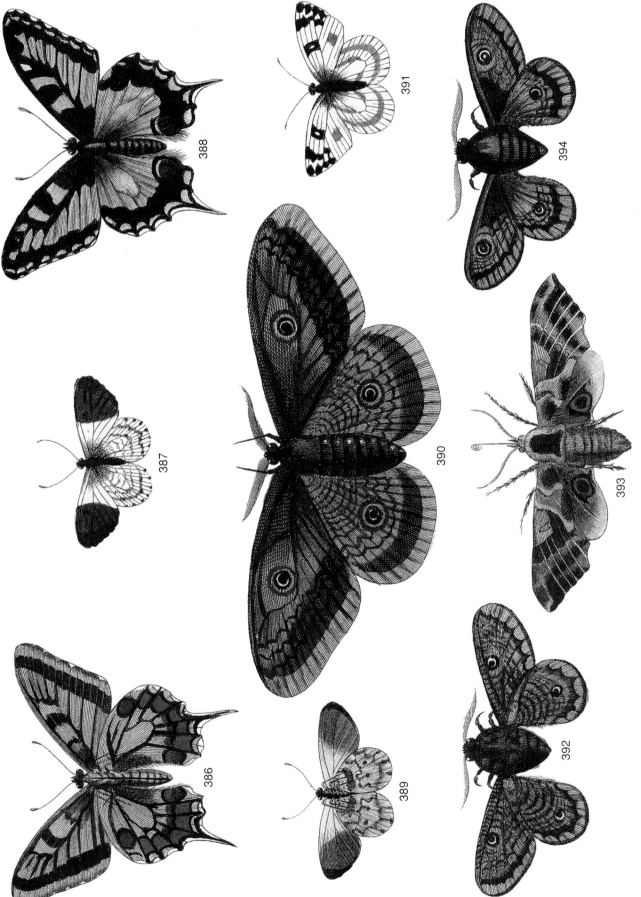

PLATE 35. BUTTERFLIES AND MOTHS. 386, 388: *Papilio machaon.* 387, 389: *Anthocharis cardamines.* 390: *Saturnia pyri.* 391: *Pontia daplidice.* 393: *Smerinthus ocellatus.*

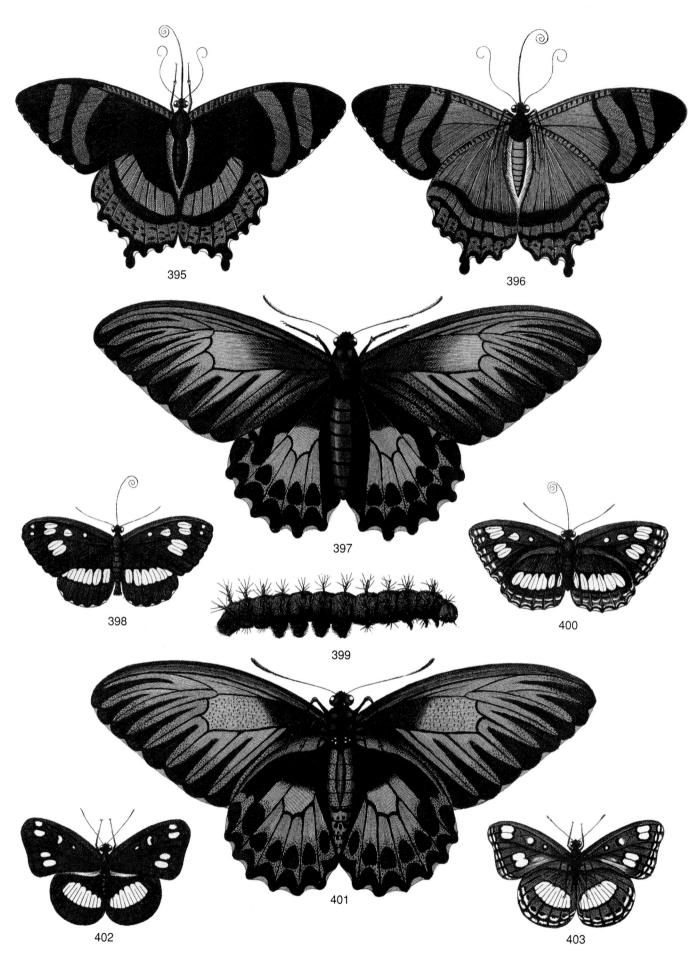

PLATE 36. MALAYSIAN, NEW GUINEAN AND AUSTRALIAN BUTTERFLIES. 395, 396: *Papilio* sp. 397, 401. *Troides oblongomaculatus.* 398, 400, 402, 403: *Pantoporia venilia.*

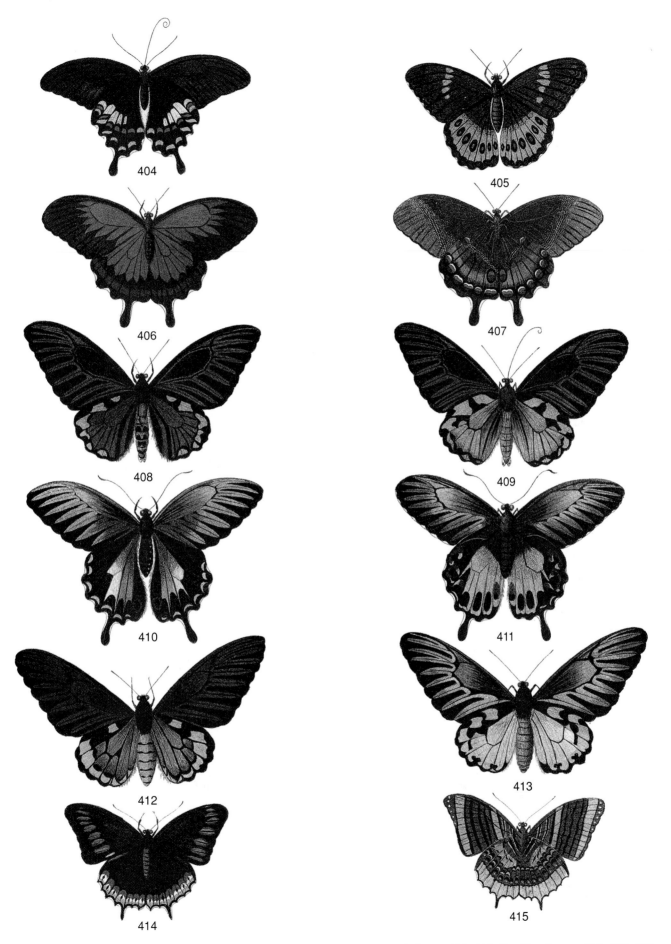

PLATE 37. SOUTHEAST ASIAN AND NORTH AFRICAN BUTTERFLIES. 404: *Papilio helenus.* 405, 411: *Papilio ulysses.* 406, 408, 412, 414: *Troides hypolitus.* 407, 413: *Papilio polytes.* 409, 415: *Charaxes jasius.* 410: *Hypolimnas pandarus.*

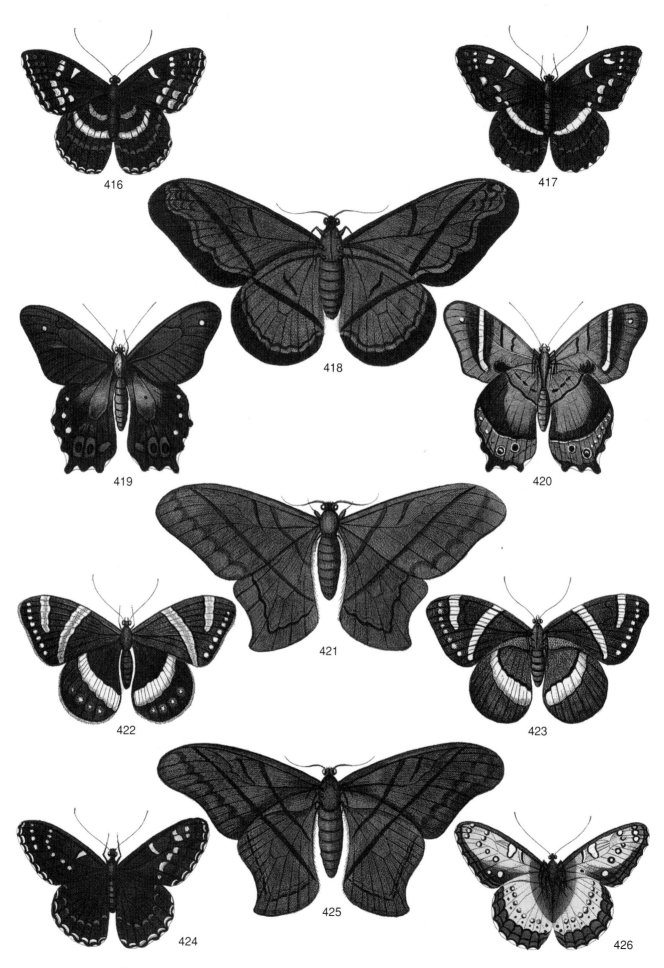

PLATE 38. SOUTH AMEICAN AND EURASIAN BUTTERFLIES AND MOTHS. 418, 421, 425: *Arsenura* sp.
419, 420: *Antirrhea philoctetes*. 416, 417, 424, 426: *Lemenitis populi*.

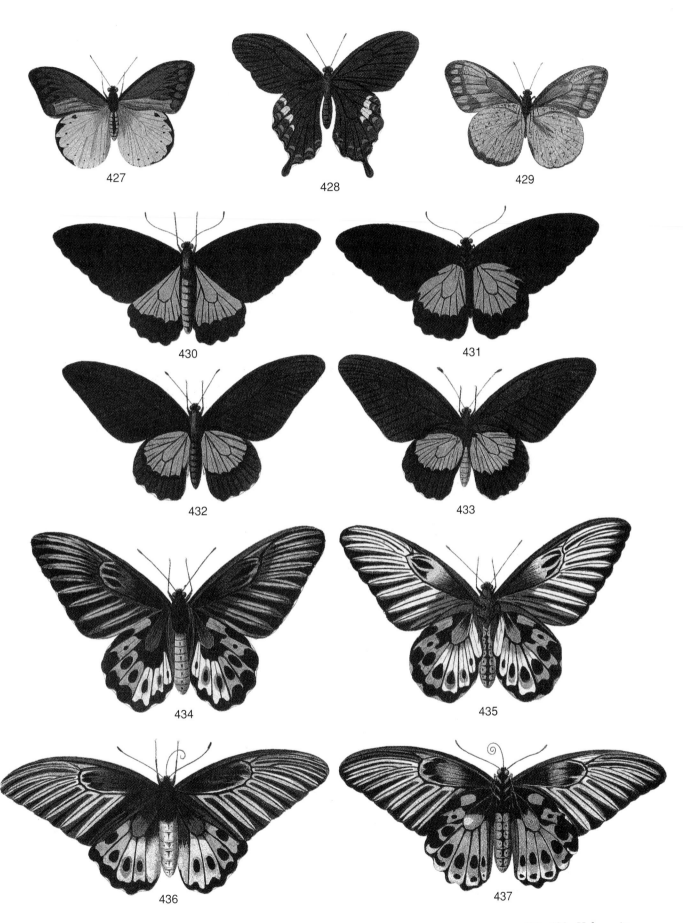

PLATE 39. SOUTHEAST ASIAN, AUSTRALIAN AND CENTRAL AND SOUTH AMERICAN BUTTERFLIES. 427, 429: *Hebomoia leucippe*. 428: *Hebomoia glaucippe*. 430–433: *Troides helena*. 434–437: *Troides hypolitus*.

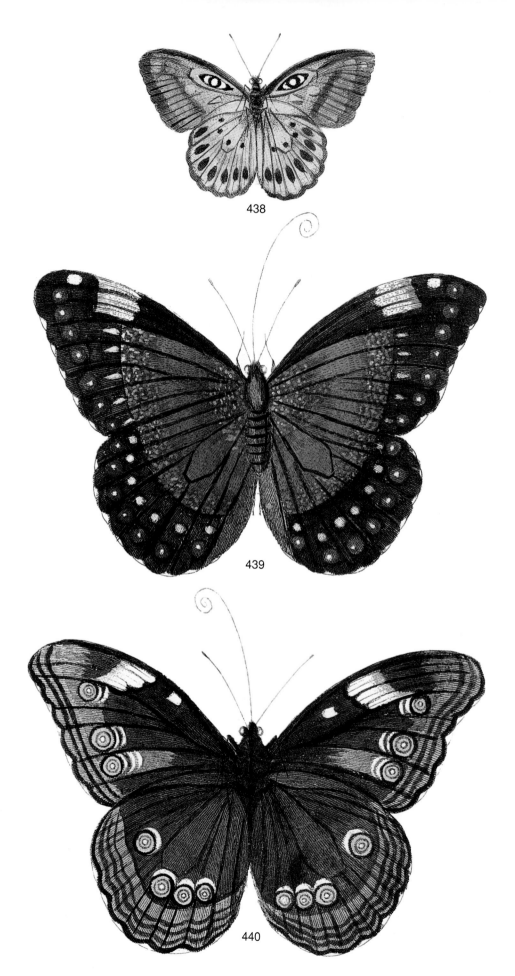

PLATE 40. AMERICAN TROPICAL BUTTERFLIES AND MOTHS. 439, 440: *Morpho peleides*.

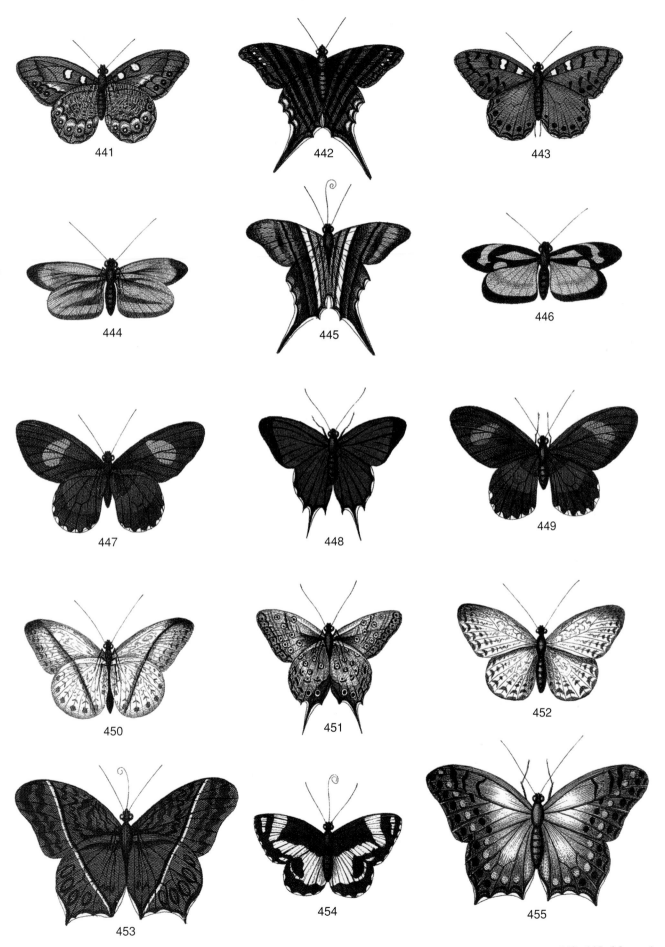

PLATE 41. AFRICAN, AMERICAN, SOUTHEAST ASIAN AND AUSTRALIAN BUTTERFLIES; SOUTH AMERICAN MOTH. 442, 445: *Marpesia chiron*. 444, 446: Arctiinae. 447, 449: *Parides* sp. 453, 455: *Charaxes varanes*. 454: *Salamis anacardi*.

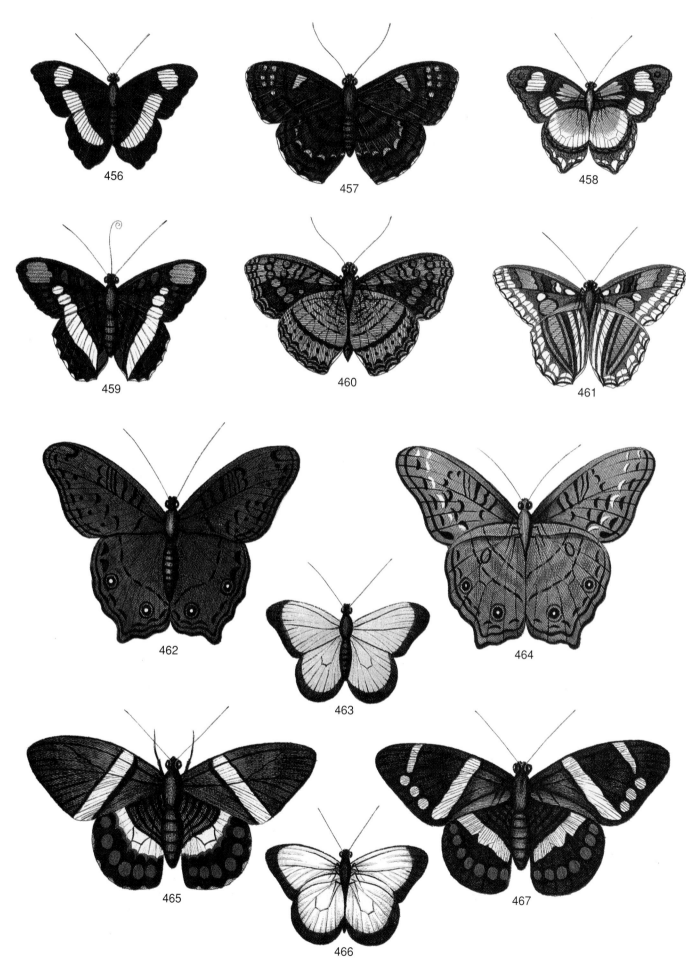

PLATE 42. BUTTERFLIES. 456, 458: *Pyrrhogyra neaerea*. 462, 464: *Vindula arsinoe*.
463, 466: *Colias*. 465, 467: *Aeropetes tulbaghia*.

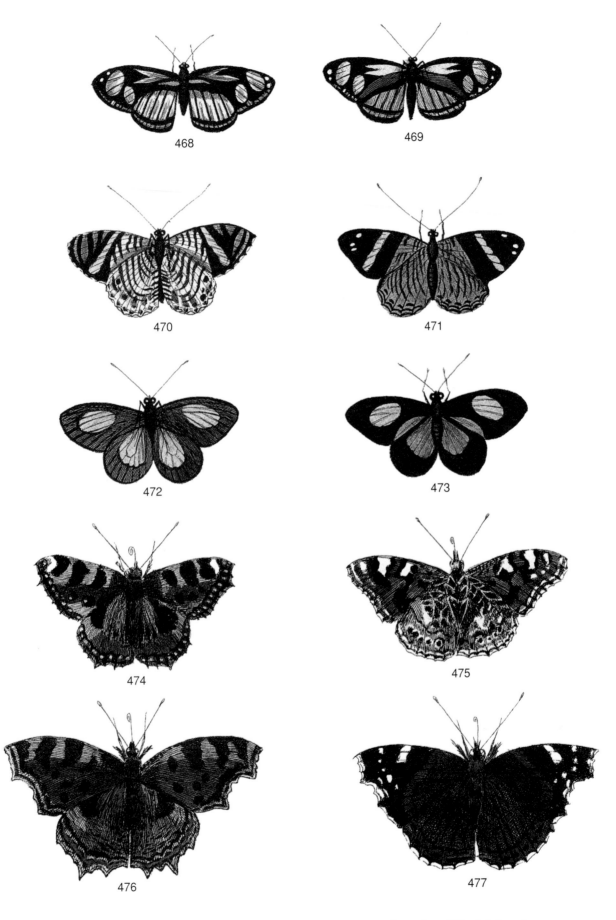

PLATE 43. BUTTERFLIES. 470, 471: *Tigridia acesta*. 472, 473: *Setabis epitus*. 474: *Aglais urticae*. 475: *Vanessa cardui*. 476: *Nymphalis polychloros*. 477. *Vanessa atalanta*.

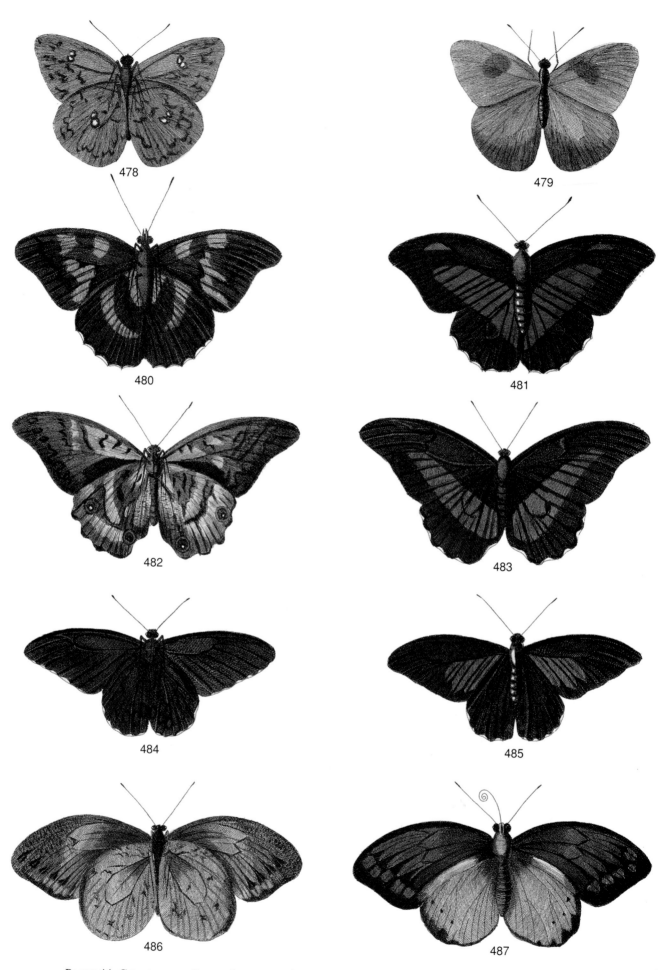

PLATE 44. CENTRAL AND SOUTH AMERICAN, AFRICAN AND MOLUCCAN BUTTEFLIES. 478, 479: Coliadinae.
480–483: *Archaeoprepona demophon*. 484, 485: *Parides sesostris*.

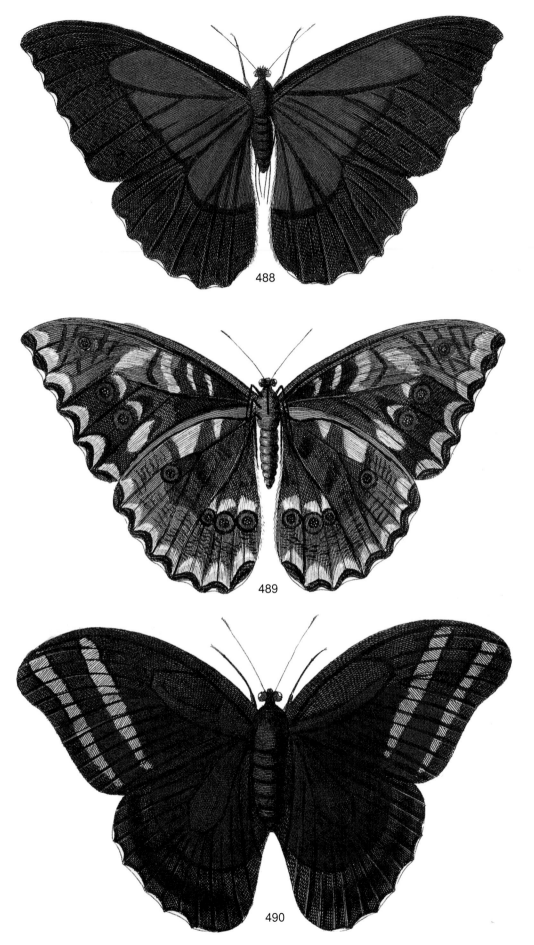

PLATE 45. CENTRAL AND SOUTH AMERICAN BUTTERFLIES. 488, 489: *Morpho menelaus*. 490: *Caligo teucer.*

INDEX